DRAW 500 AWESOME ANIMALS

A Sketchbook for Artists, Designers, and Doodlers

JULIA KUO

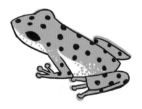

QUARRY

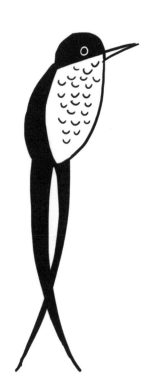

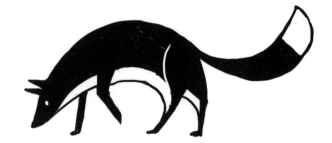

HOW TO USE THIS BOOK

This book features 500 drawings of all sorts of creatures, big and small. You will see that most of these drawings are comprised of simple combinations of lines and shapes. When you look at an animal you want to draw, what do you see? Are there squares, circles, or triangles? Are the outlines of the shape straight, curved, or wiggly? When drawing animals, look for the big shapes and lines first, and then add in the smaller details.

Use the illustrations in this book as inspiration. You can trace them, copy them, or change the details to draw your own versions. There's plenty of blank space to draw right in the book, so grab a pencil, pen, marker, or brush, and have fun drawing 500 more animals of your own!

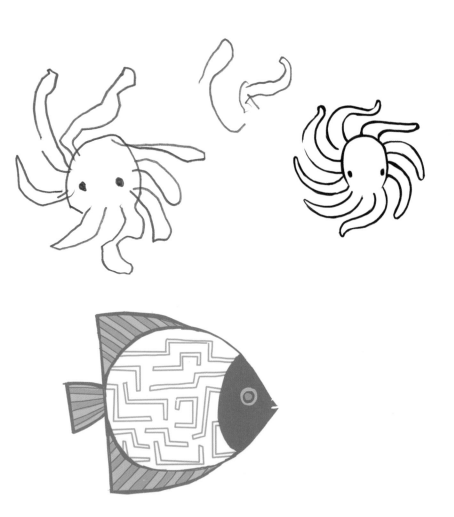

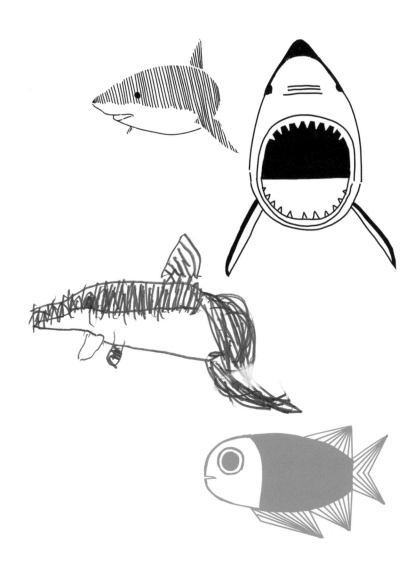

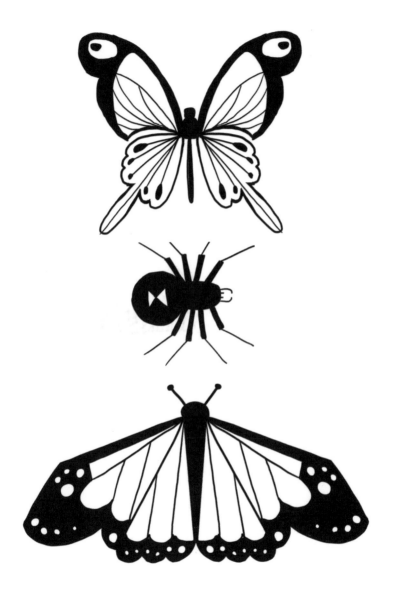

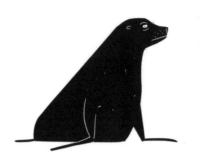

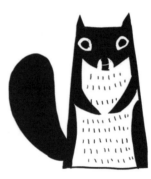

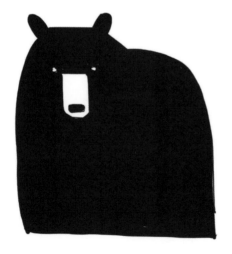

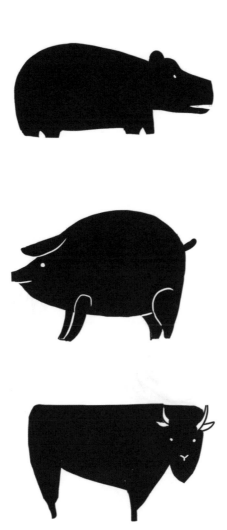

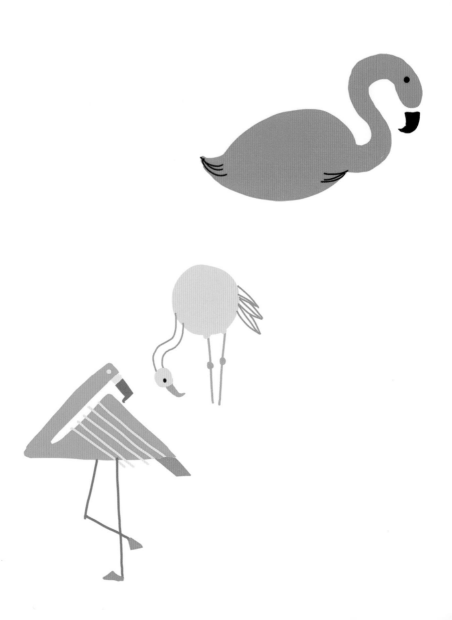

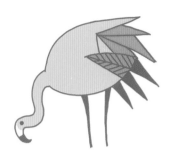

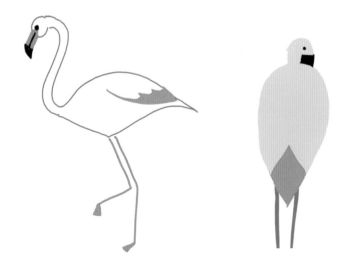

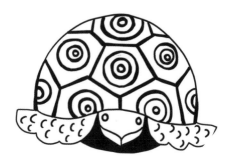

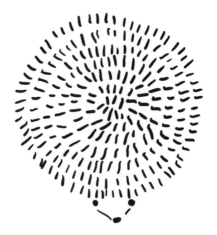

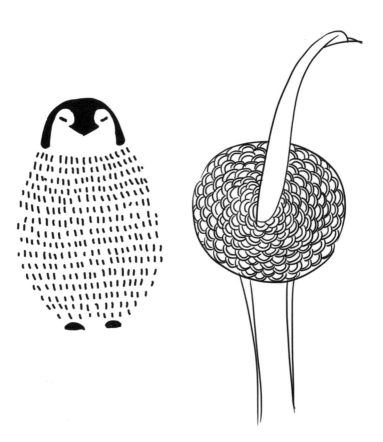

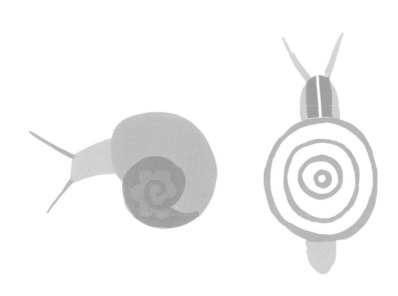

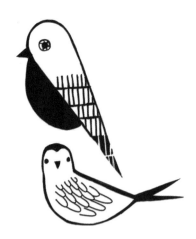

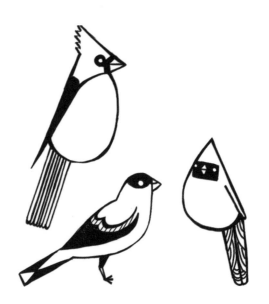
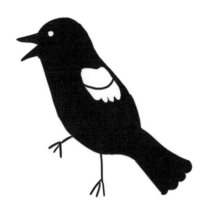

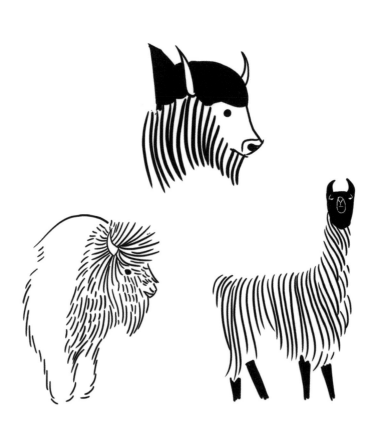

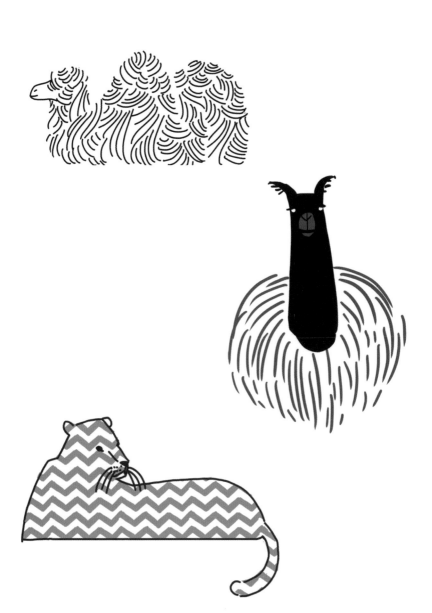

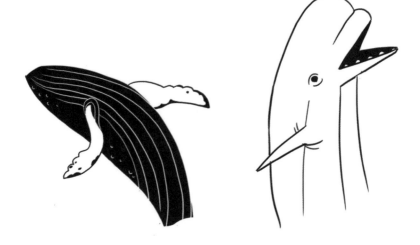

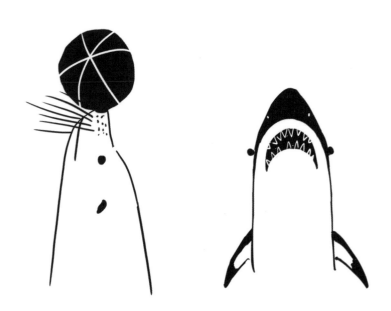

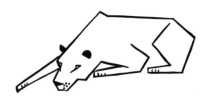

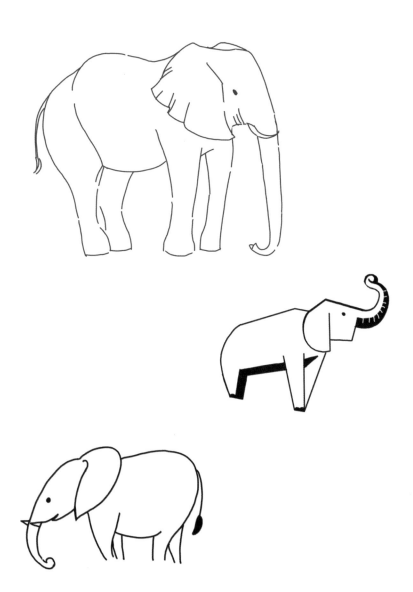

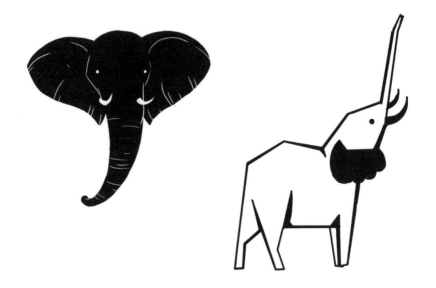
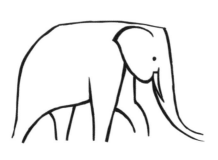

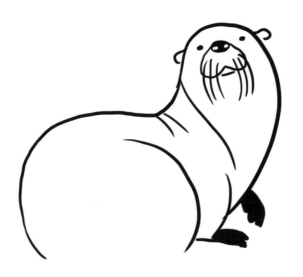

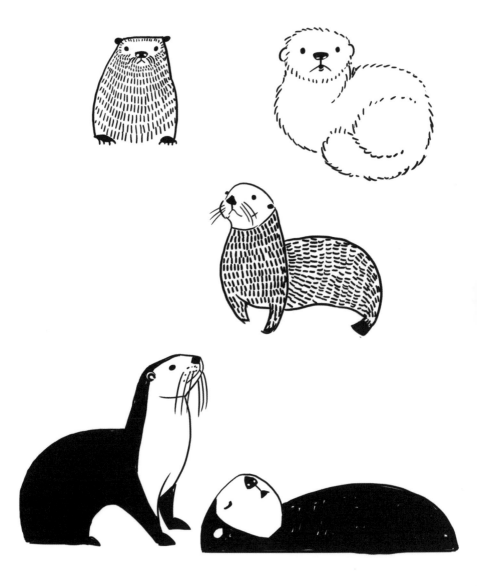

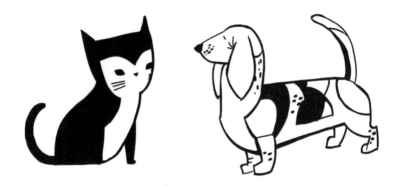

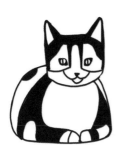
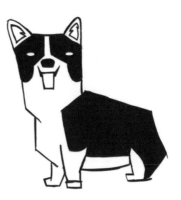

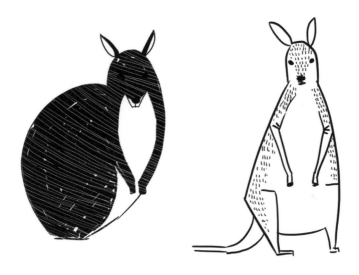

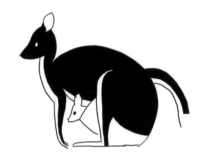

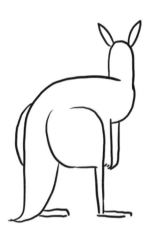

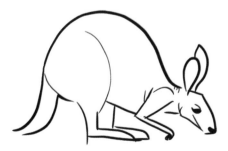

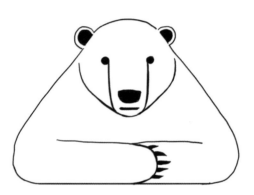

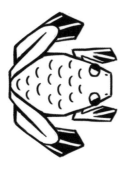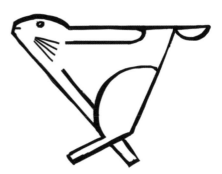

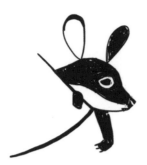

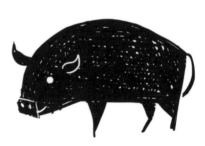

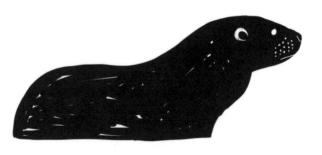

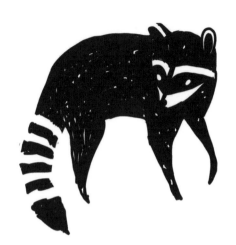

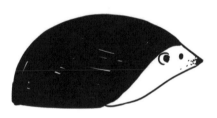

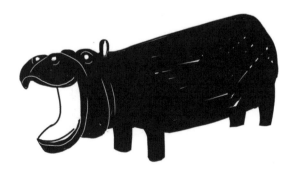

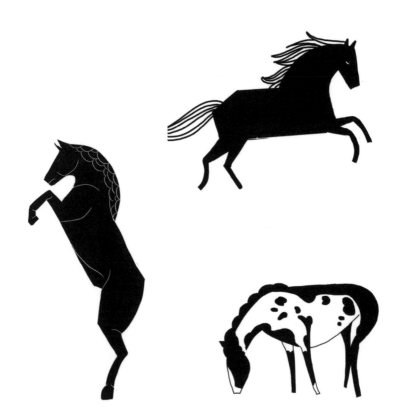

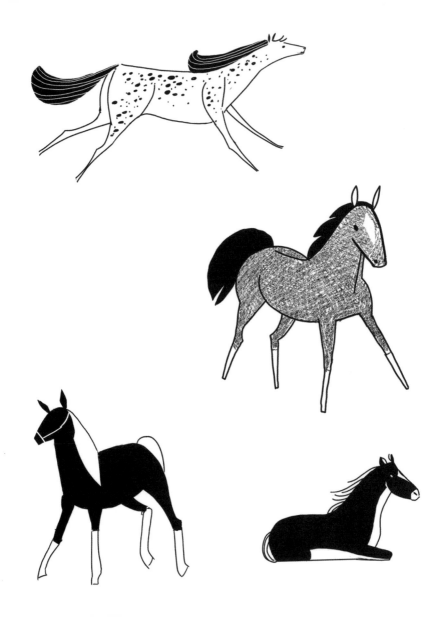

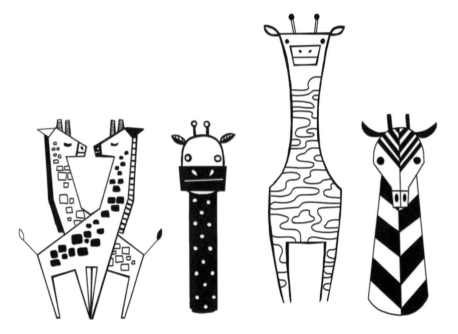

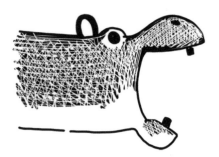

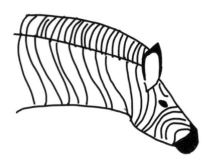

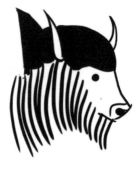

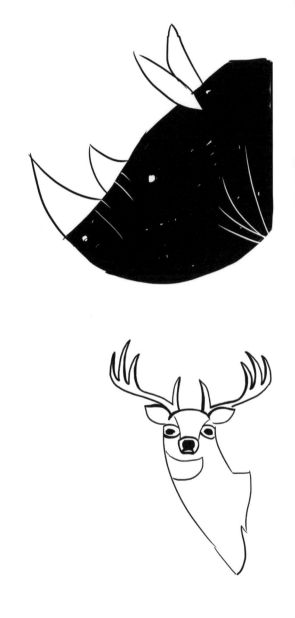

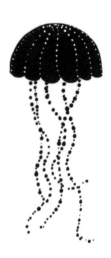

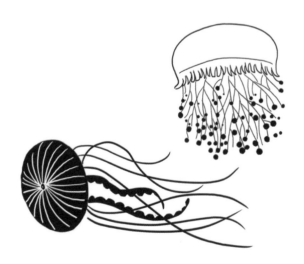

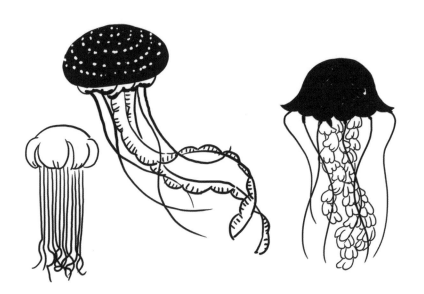

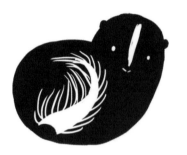

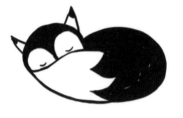

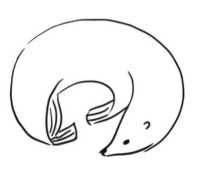

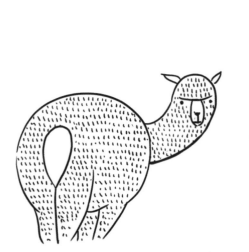

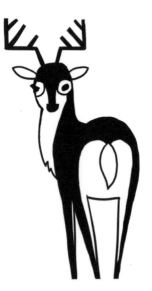

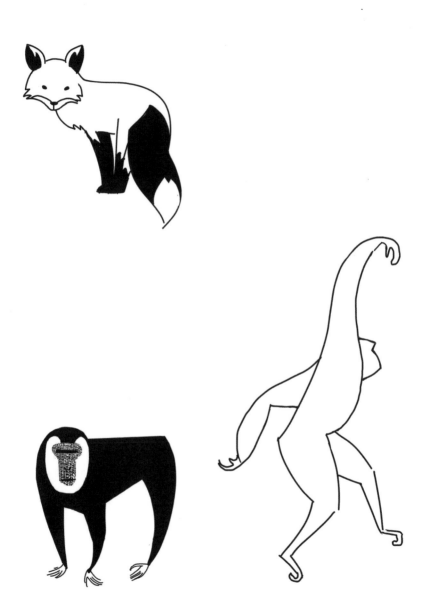

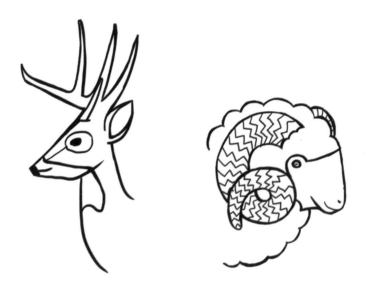

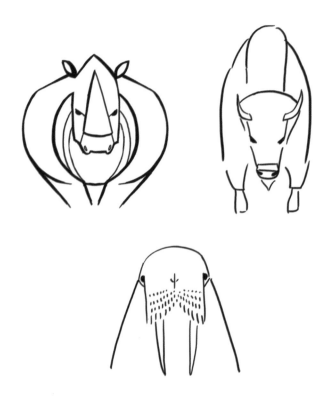

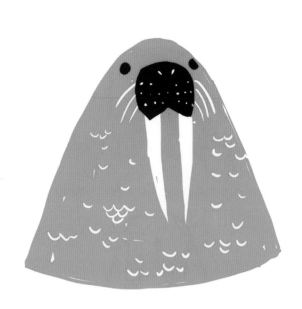

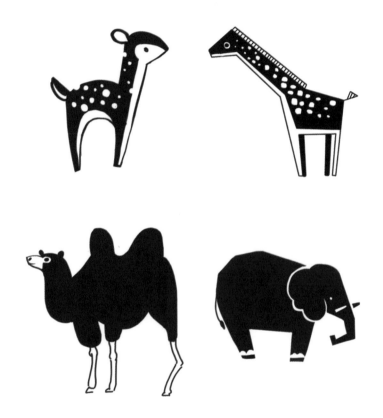

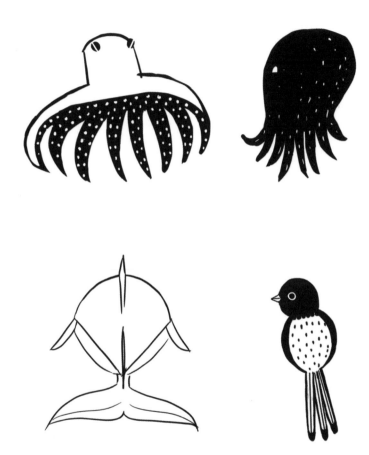

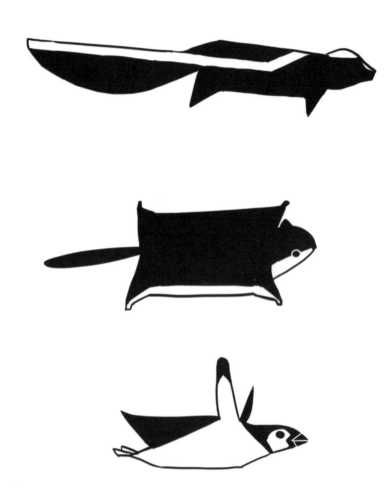

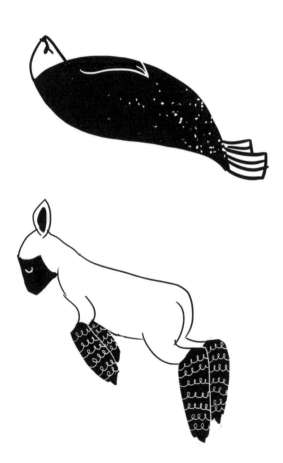

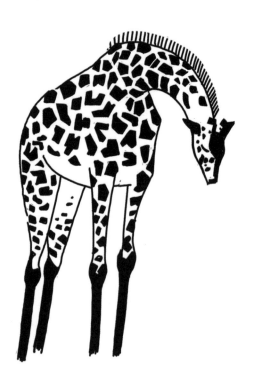

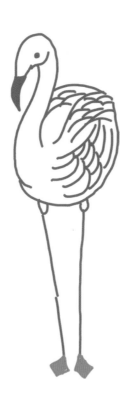

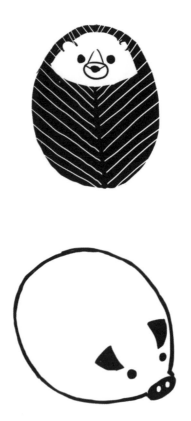

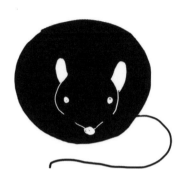

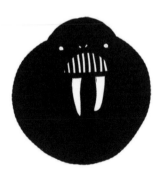

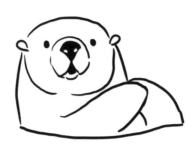

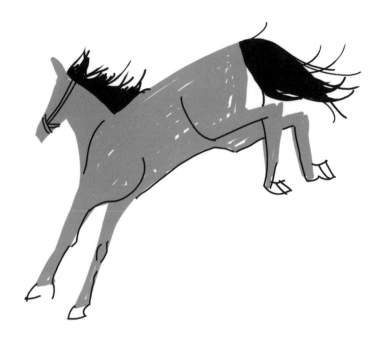

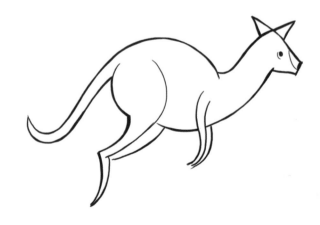

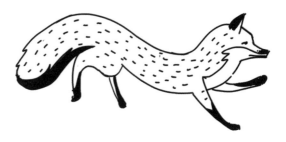

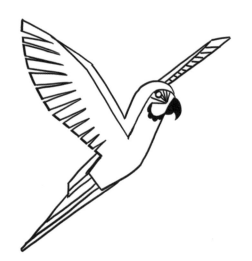

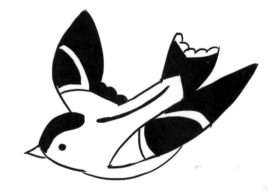

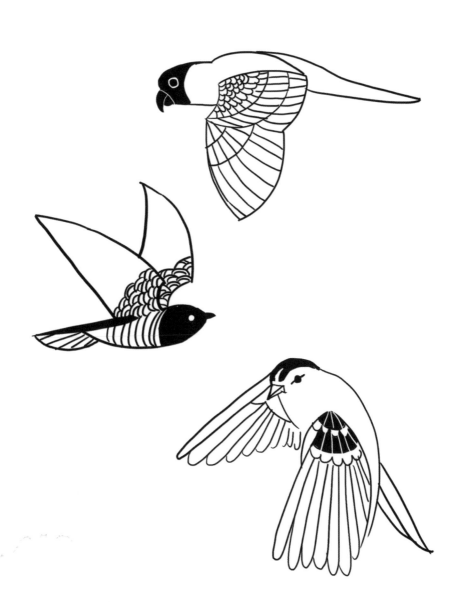

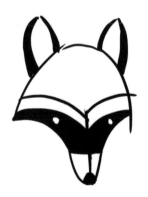

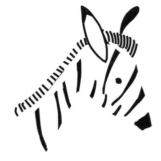

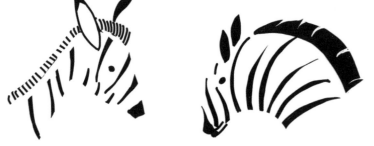

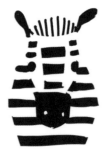

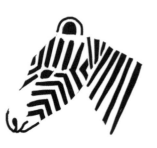

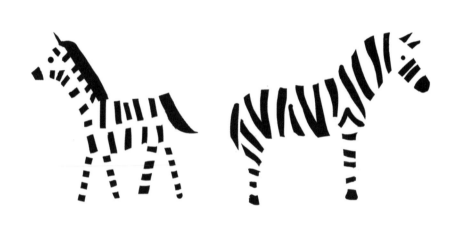

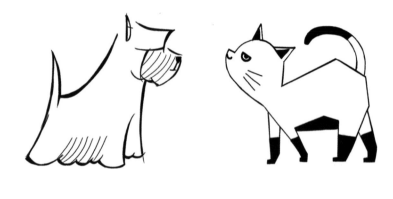

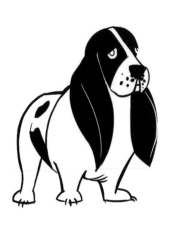

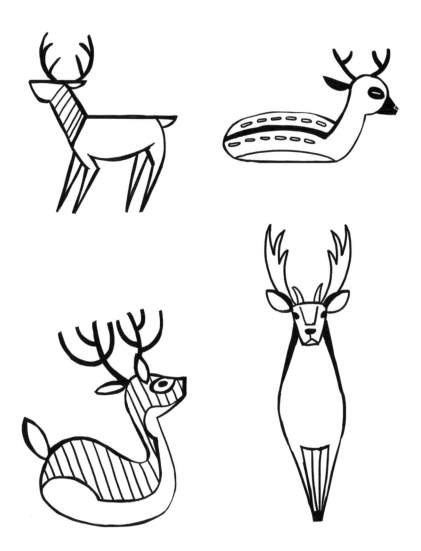

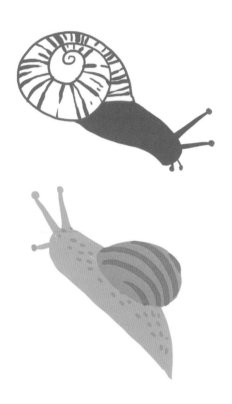

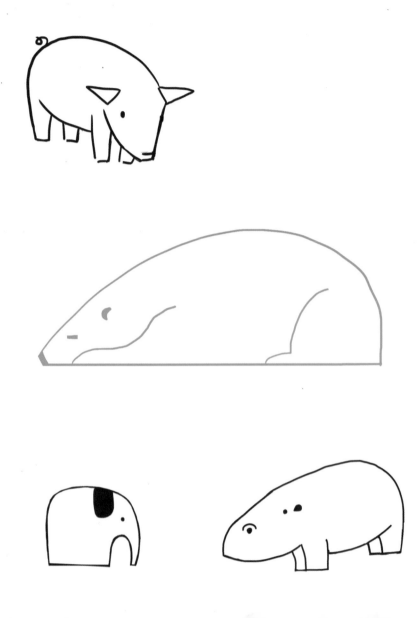

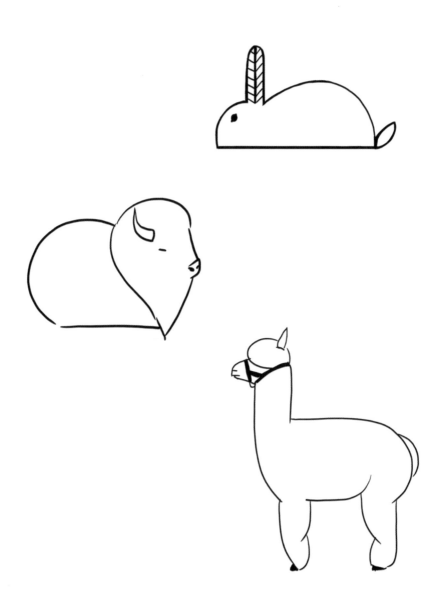

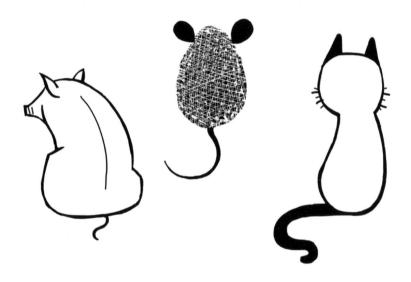

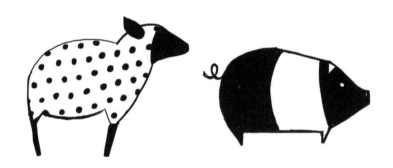

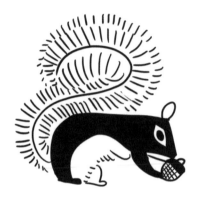

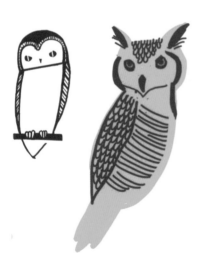
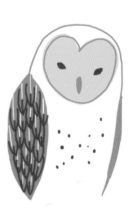

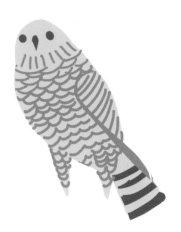

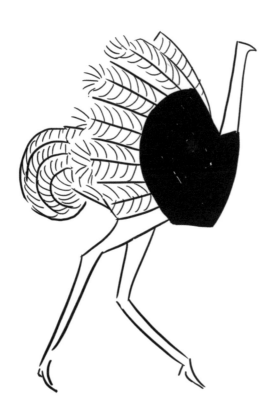

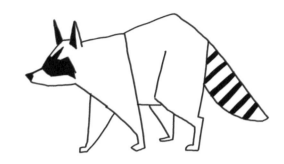

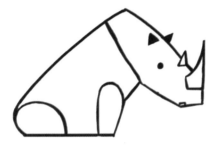

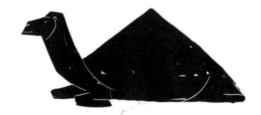

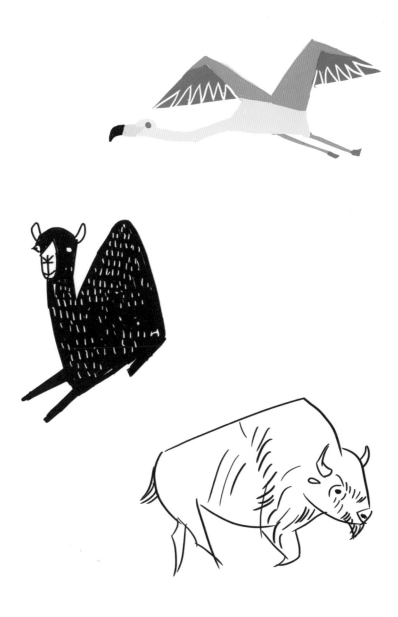

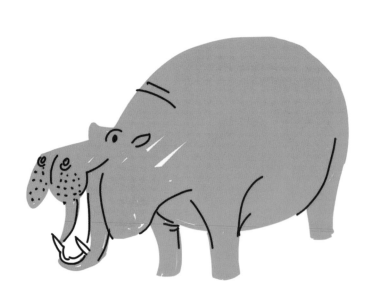

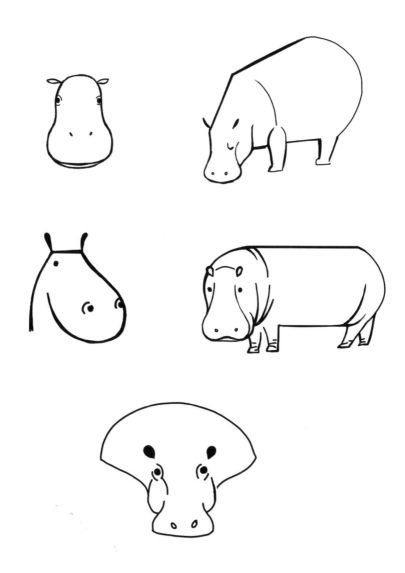

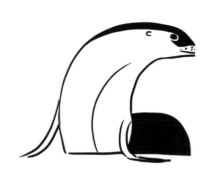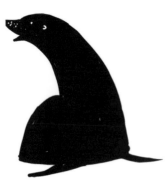

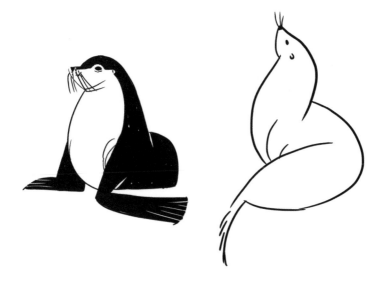

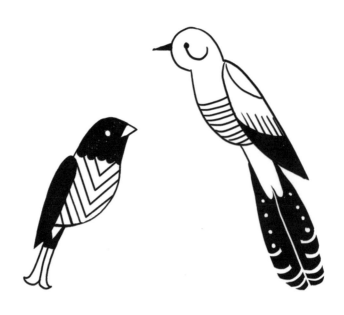

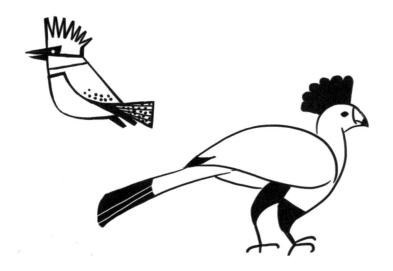

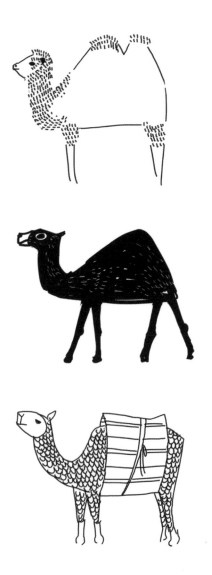

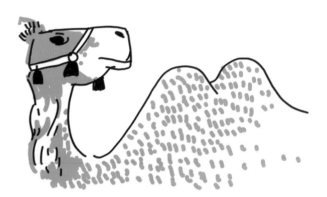

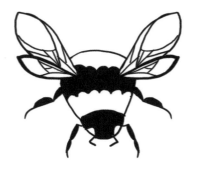

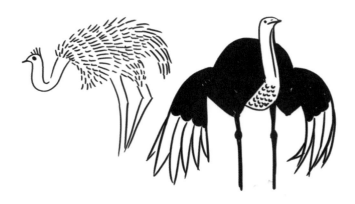

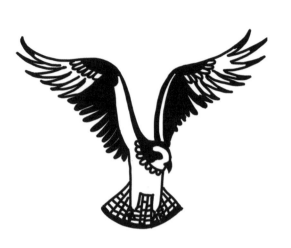

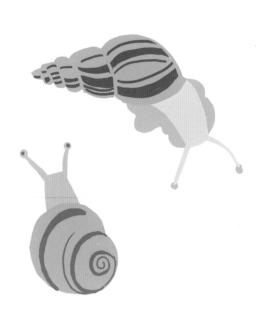

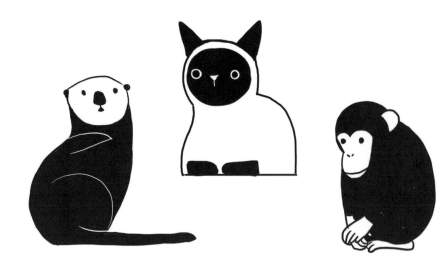

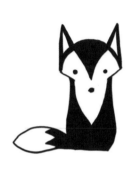 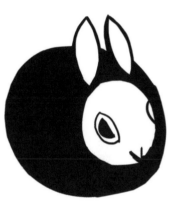

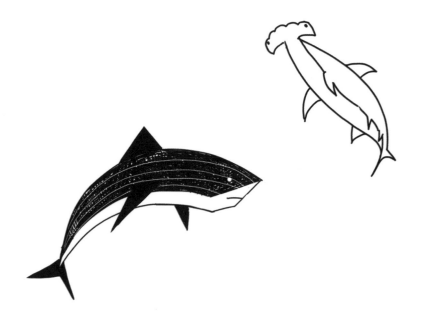

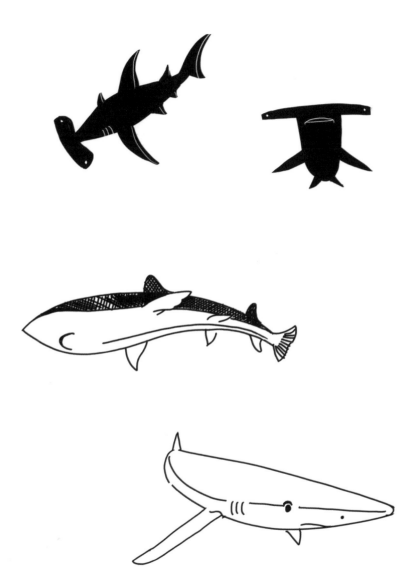

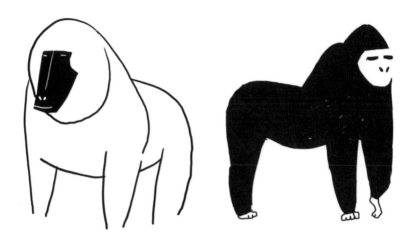

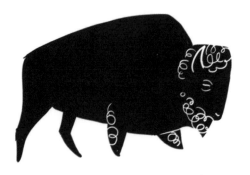

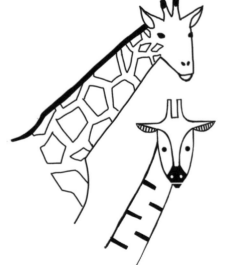

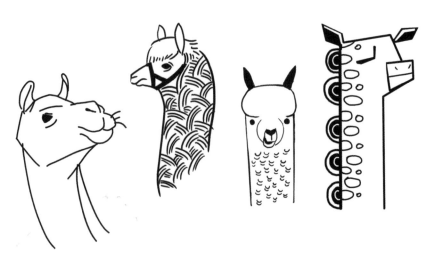

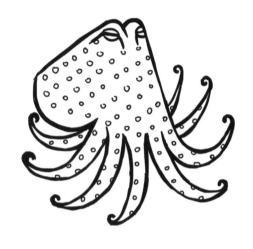

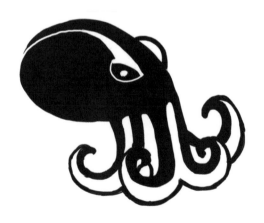

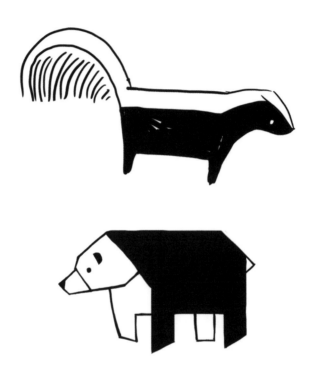

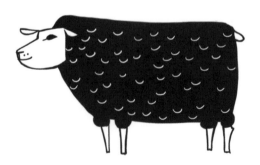

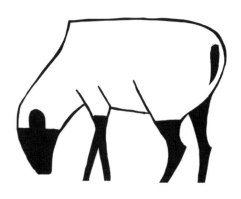

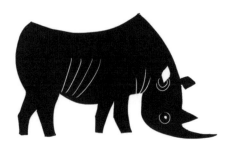

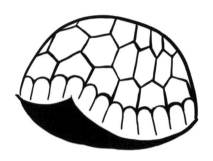

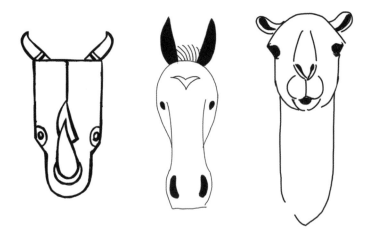

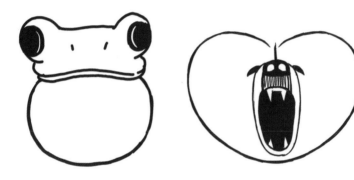

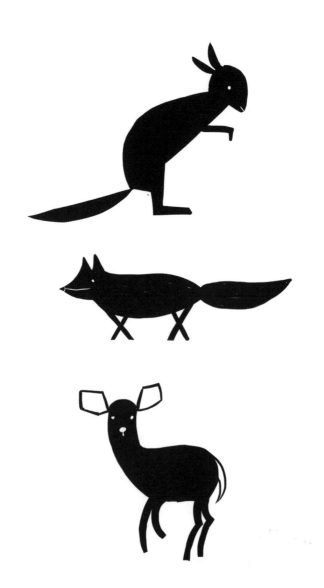

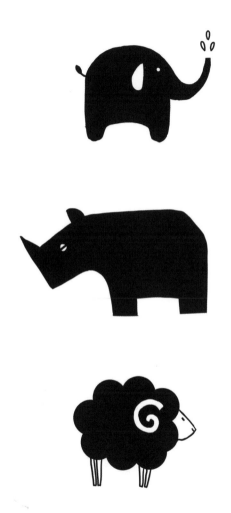

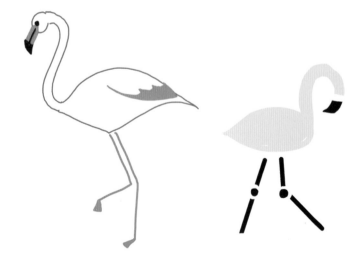

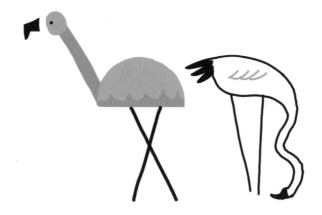

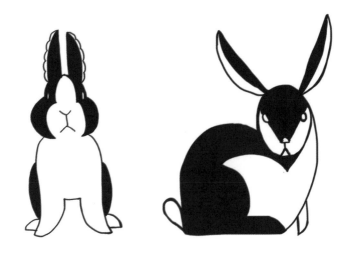

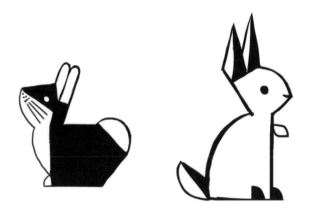

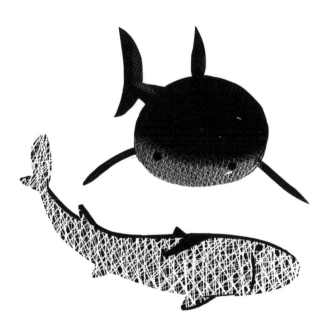

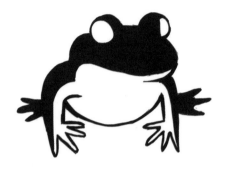

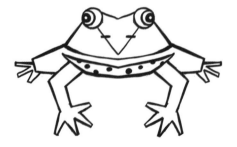

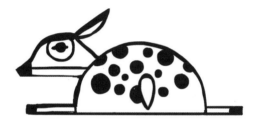

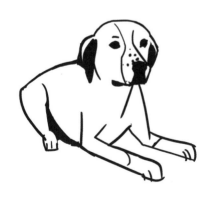

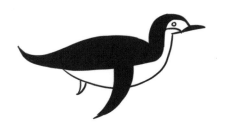

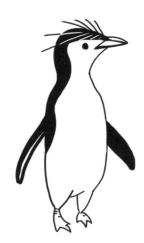

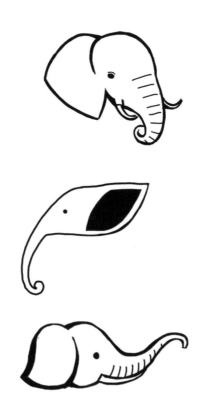

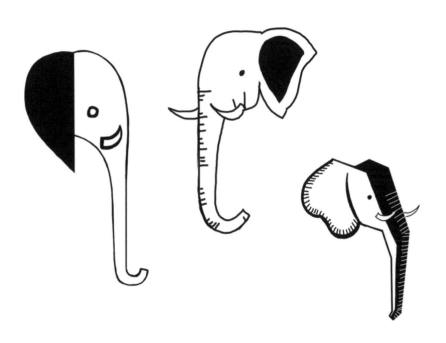

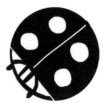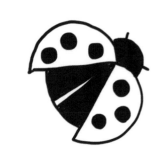

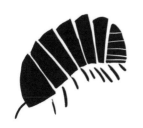

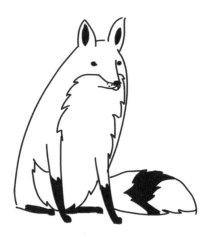

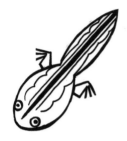

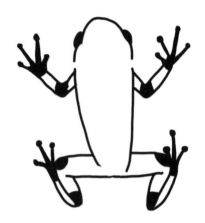

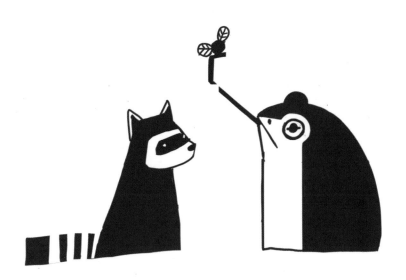

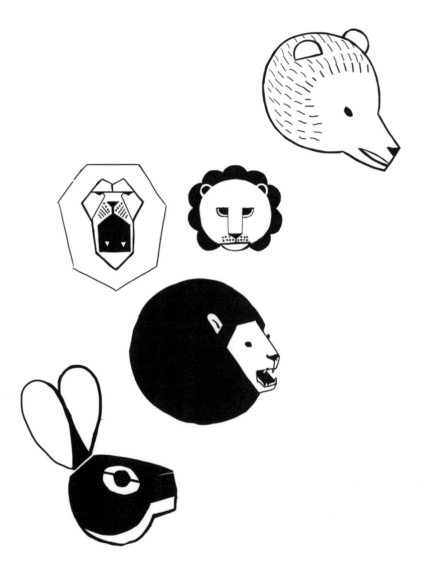

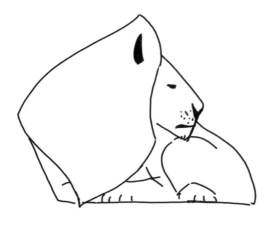

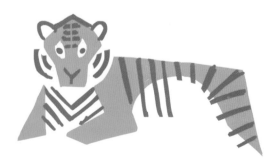

ABOUT THE ARTIST

Julia Kuo grew up in Los Angeles, California, and studied illustration and marketing at Washington University in St. Louis. She currently works as a freelance illustrator in Chicago for most of the year and in Taipei, Taiwan, during the winter. Julia designs stationery and illustrates children's books, concert posters, and CD covers. Her clients include American Greetings, the *New York Times*, Little, Brown and Company, Simon and Schuster, Capitol Records, and Universal Music Group. Julia is part of The Nimbus Factory, a collective of two designers and two illustrators specializing in paper goods. Her illustrations have been honored in *American Illustration, CMYK* magazine, and *Creative Quarterly*. She is the featured artist in *20 Ways to Draw a Dress and 44 Other Fabulous Fashions and Accessories*, Quarry Books, 2013. See more of her work at juliakuo.com.

First published in 2014 by Quarry Books,
an imprint of The Quarto Group,
100 Cummings Center, Suite 265-D,
Beverly, MA 01915, USA.
T (978) 282-9590 F (978) 283-2742
www.QuartoKnows.com

Quarry Books titles are also available at discount for retail, wholesale, promotional, and bulk purchase. For details, contact the Special Sales Manager by email at specialsales@quarto.com or by mail at The Quarto Group, Attn: Special Sales Manager, 401 Second Avenue North, Suite 310, Minneapolis, MN 55401, USA.

10 9 8 7 6 5 4 3 2

ISBN: 978-1-59253-990-1

All artwork compiled from *20 Ways to Draw a Cat and 44 Other Awesome Animals*, Quarry Books, 2013

Design: Debbie Berne

Printed in China

MIX
Paper from
responsible sources
FSC® C016973
FSC
www.fsc.org